Beauty's in Nature

Jennene Christine Obremski

Copyright © 2017 Jennene Christine Obremski

All rights reserved.

ISBN: **10:1548043249**

ISBN-13: **978-1548043247**

DEDICATION

This book is dedicated to survivors of child sexual, physical and emotional abuse and/or neglect.

Jennene Christine Obremski

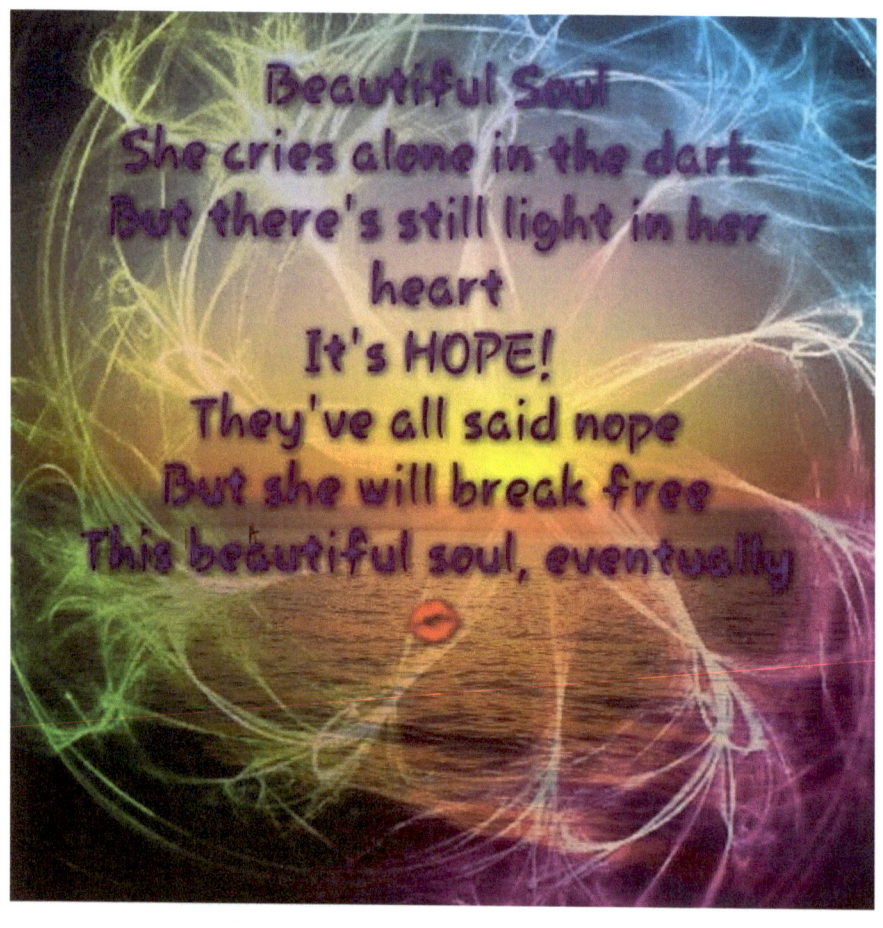

Beauty's in Nature

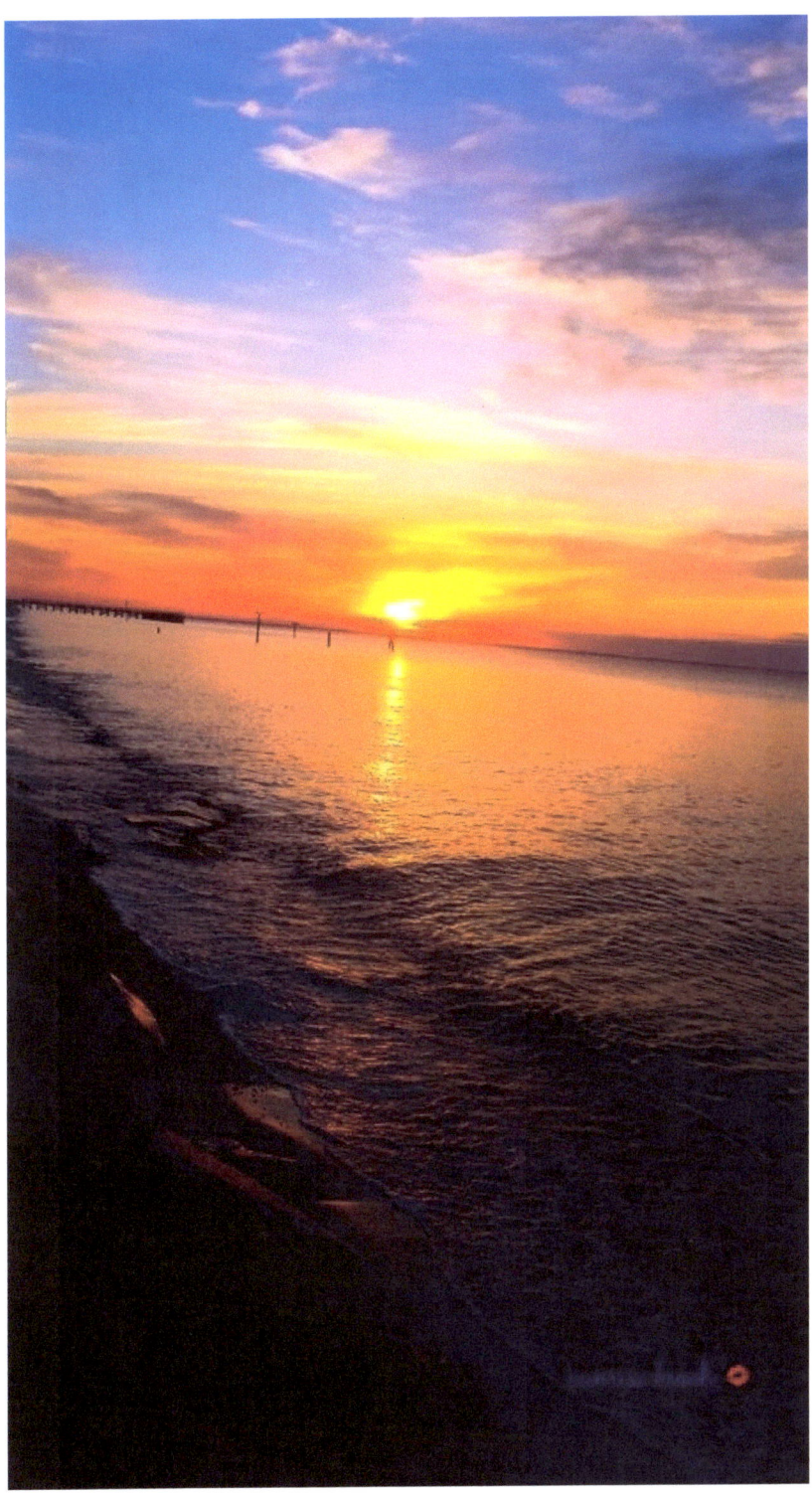

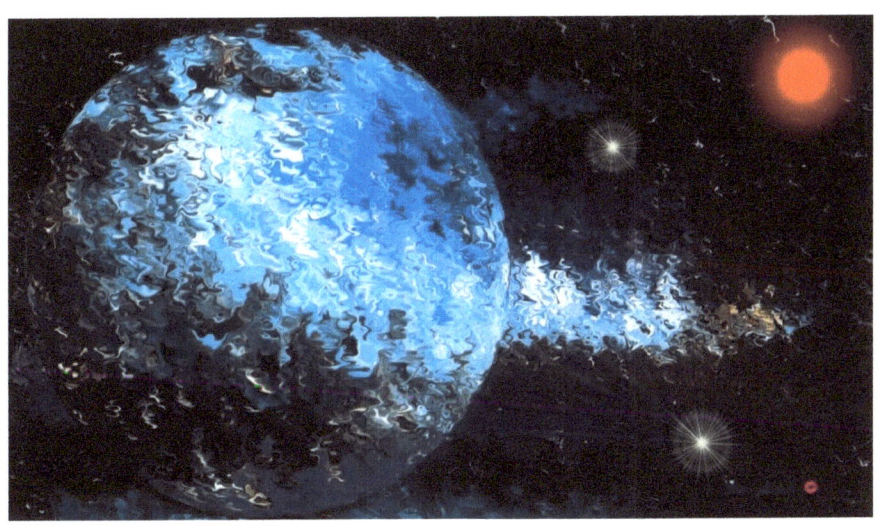

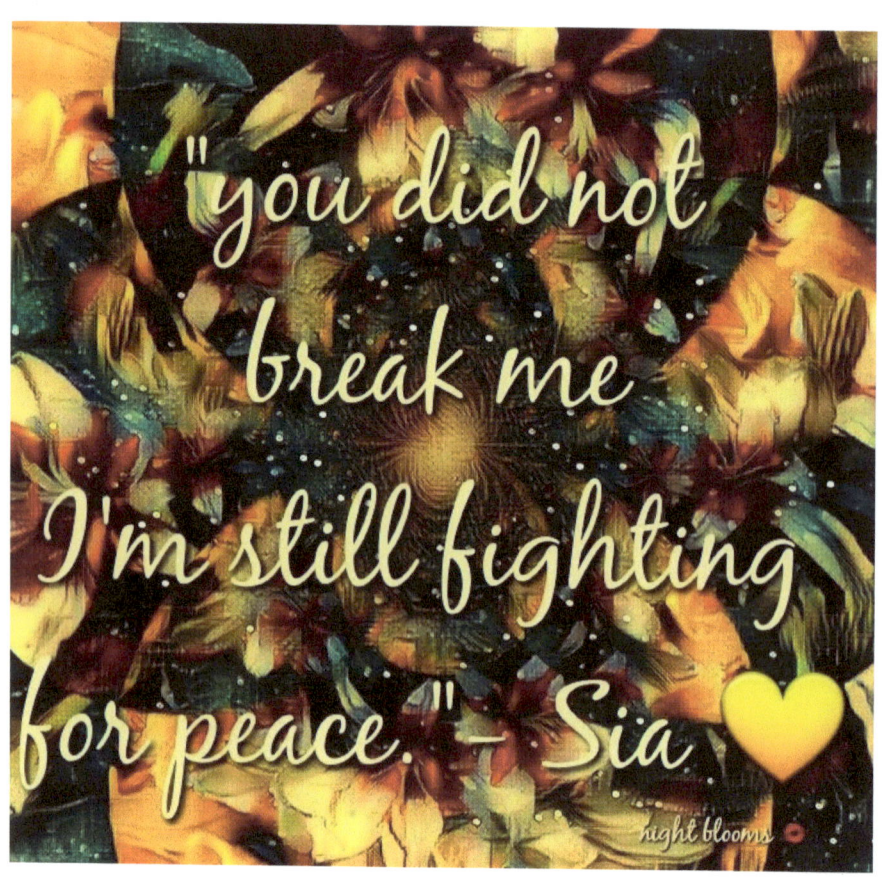

Jennene Christine Obremski

Jennene Christine Obremski

Beauty's in Nature

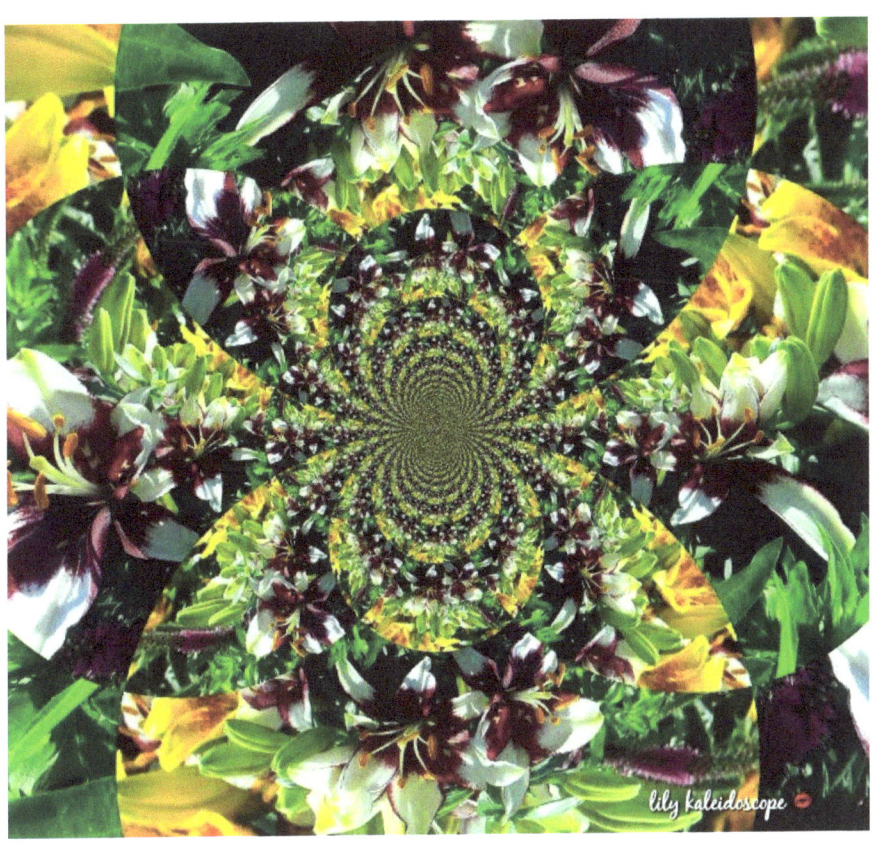

Jennene Christine Obremski

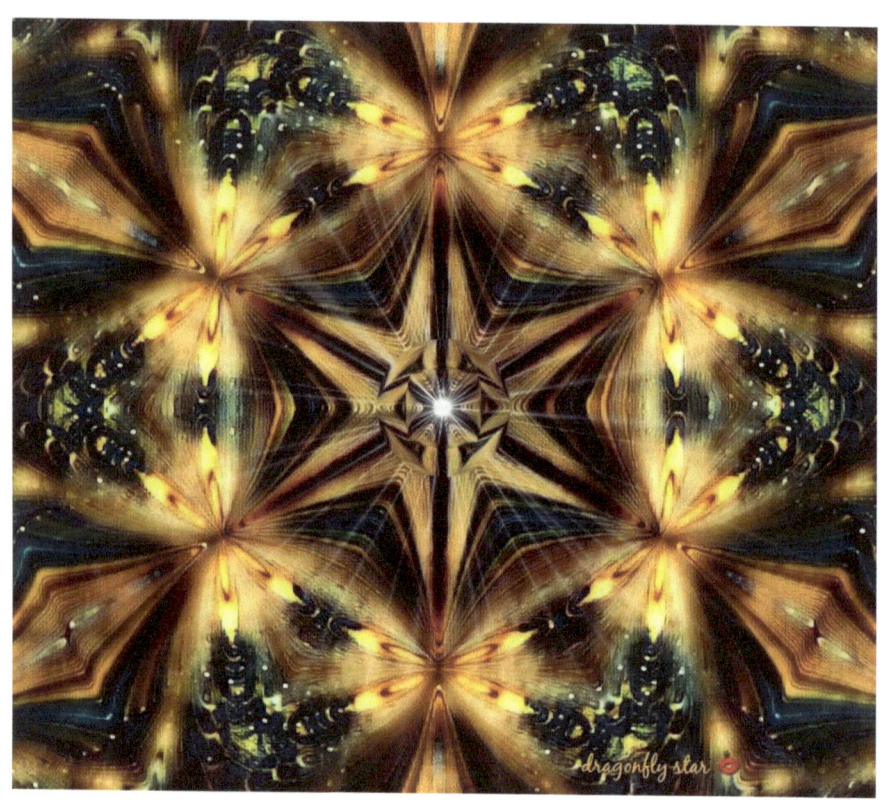

Beauty's in Nature

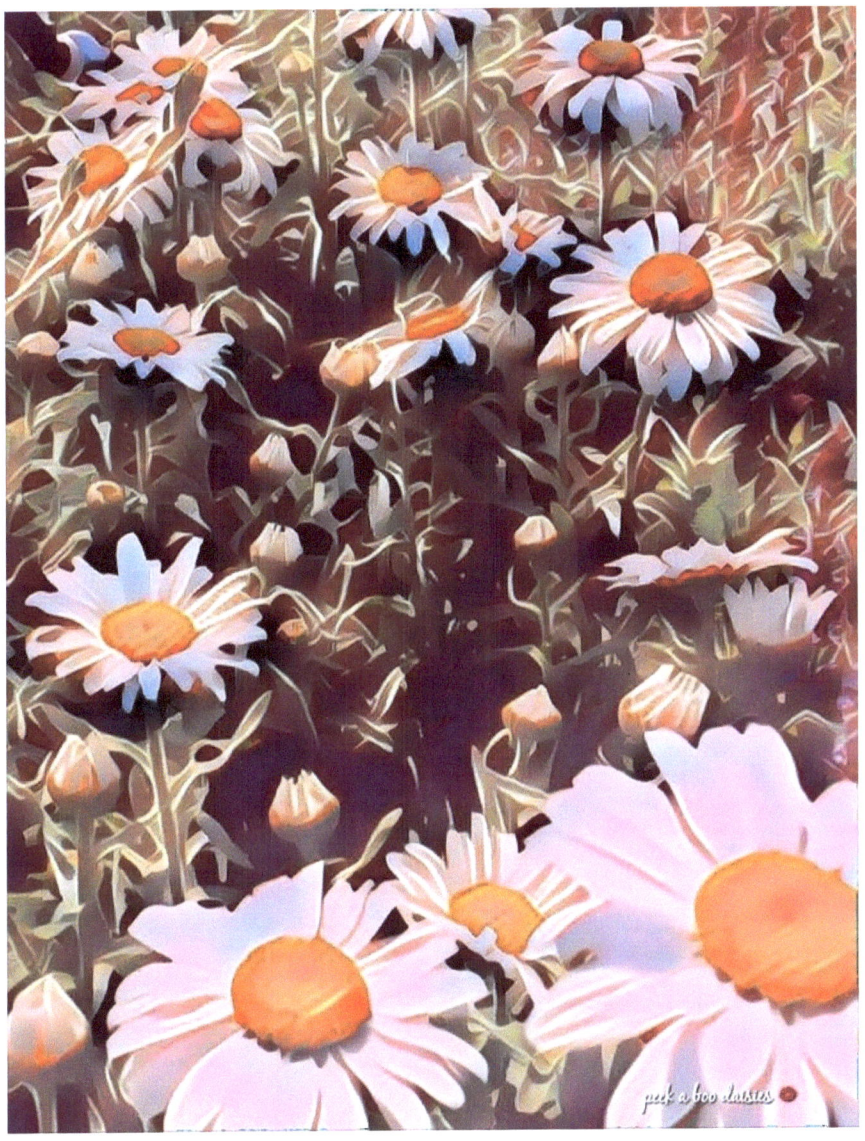

Jennene Christine Obremski

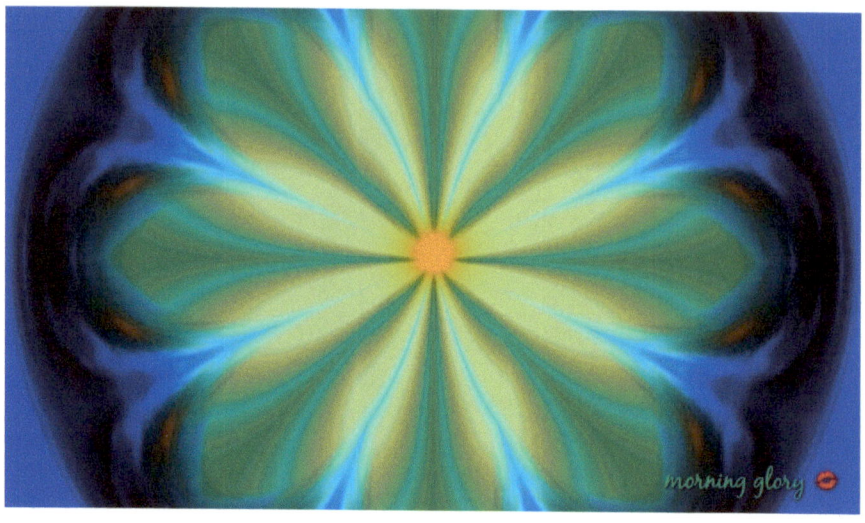

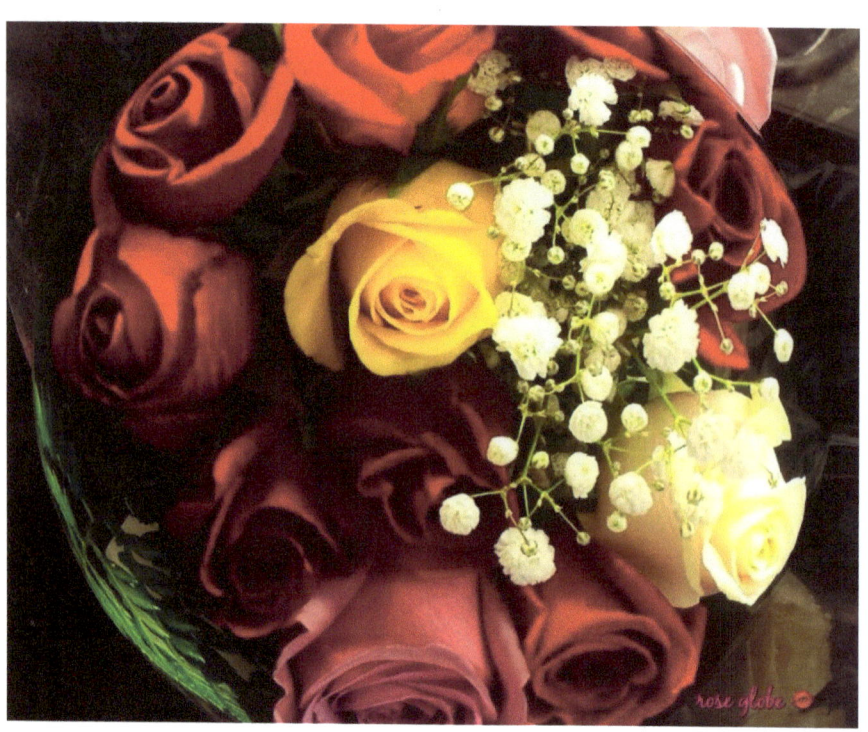

Beauty's in Nature

dragonfly landing on a flower

golden dragonfly

Jennene Christine Obremski

Jennene Christine Obremski

Beauty's in Nature

Jennene Christine Obremski

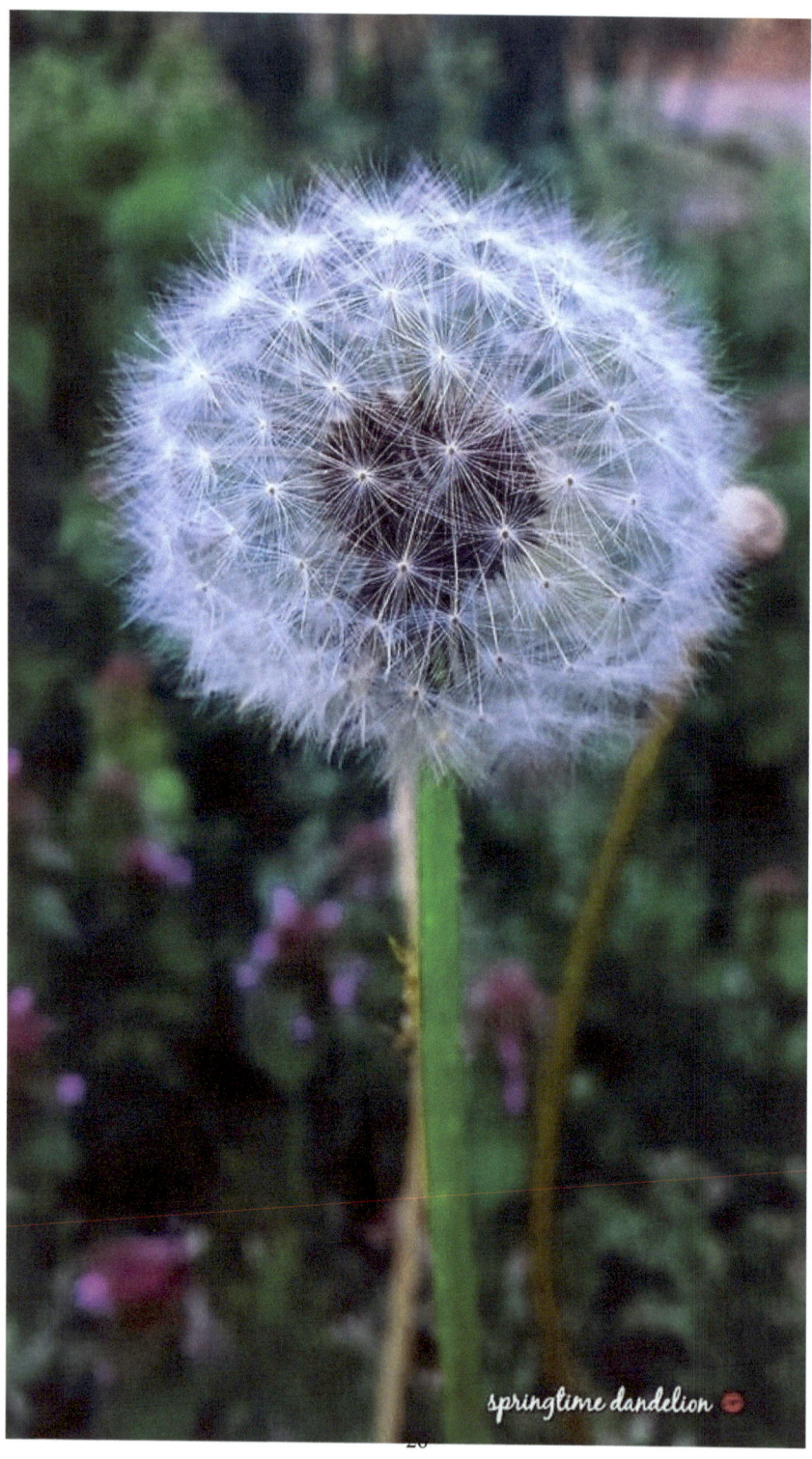

springtime dandelion

Jennene Christine Obremski

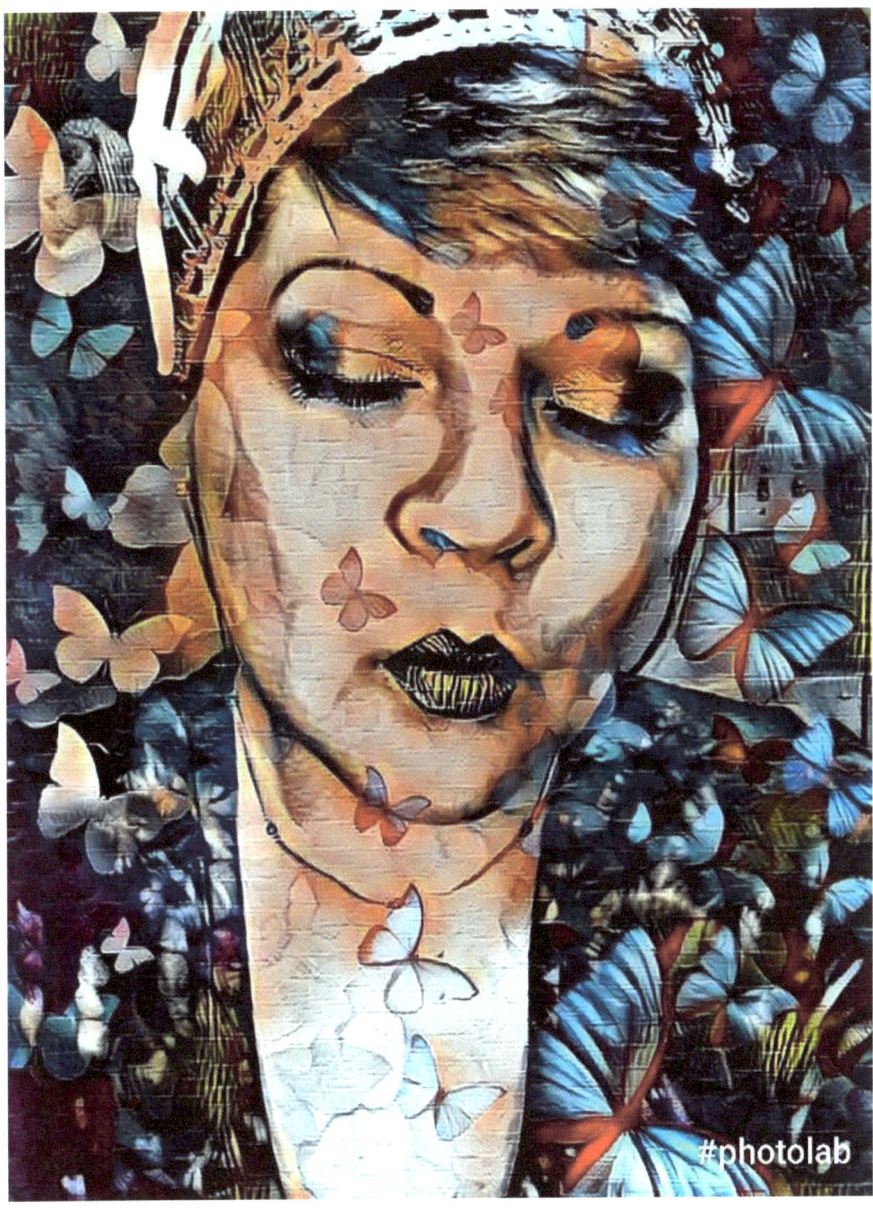

Jennene Christine Obremski

ABOUT THE AUTHOR

Jennene suffered physical and emotional abuse as well as neglect at the hands of her own mother from age 1 to when she finally stood up for herself at age 17. She was raised by her grandmother from the age of 2 to 12 but would visit her mother's house on the weekends where she was either neglected or abused physically by day and sexually molested by her mother's drunk friends and relatives by night. Eventually she was torn from her grandmother and lived with her abusive mother for good at age 12. She lived like this until she moved out with her daughter at age 19 after meeting and falling in love and marrying in the same year her husband Ken while still attending University. She ended all communications with her continually verbally and emotionally abusive mother finally in 2014. Jennene began her journey of healing through her art and writing and being of service to others by being an interpreter of her native tongue and helping to counsel fellow abuse survivors that she meets along her journey. She has books on amazon.com also available on kindle and createspace.com. Jennene's grandmother who raised her was her clan's last matriarch and she is next in line to take the honor of leading young people of her clan into the modern future. Her clan is scattered throughout Guam, Hawaii Saipan and the U.S. She enjoys art in every form, especially listening to music such as artists such as Sia while she does her digital art, early mornings and finds healing through listening to music, her art, writing poetry, helping other survivors, caring for her furbabies and family and friends.

www.ingramcontent.com/pod-product-compliance
Lightning Source LLC
Chambersburg PA
CBHW041118180526
45172CB00001B/316